TRACE & COLOR
IN ANY MEDIUM

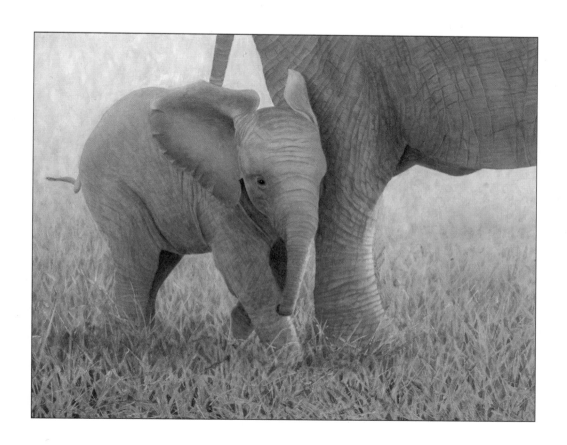

WILD ANIMALS

Contents

How to Use This Book

Laying a foundation for your own professional-looking artwork has never been so easy. Included in this book, you'll find six removable 11" x 12" sheets with line-art templates designed to be used on 9" x 12" canvas or paper, along with four sheets of graphite paper. Simply transfer the line art to your surface with the enclosed graphite paper and add color. With the helpful resources provided in this book, you're just steps away from beautiful, colorful artwork—created by you!

Step One
Decide how you will add color to your new masterpiece. This decision will impact what type of paper or canvas you should use. You can use paints, colored pencils, pastels, or markers!

Step Two
Gather the necessary materials to begin your art project. You'll find helpful tips and techniques for several types of media on pages 8-19 to help you get started.

Step Three
Gently tear out the template you wish to use along the perforated edge. Then lay a sheet of the provided graphite paper over your canvas or paper. Lay the template over the graphite paper, and trace the lines with a drawing pencil to transfer the lines to your surface.

Step Four
Add color! For inspiration, you'll find a suggested color palette and a finished color final for each template. However, this is *your* masterpiece—you can use any colors you choose!

Using Graphite Paper
Graphite paper is coated on one side with graphite, making it easy to transfer a light line drawing to your chosen surface. Place a sheet of graphite paper over clean drawing paper or canvas. Then place the line-art template over the graphite paper. Tape or hold the papers together and lightly trace the outline. The lines of your sketch will transfer onto the surface below.

Checking your Lines While tracing the lines, occasionally lift the corner to make sure the transferred lines aren't too light or too dark.

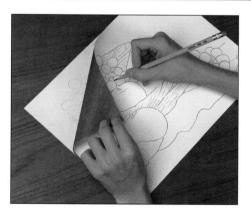

Working in Other Sizes
You can resize the templates in this book to fit other standard-size canvases or paper. Simply reduce or enlarge the template on a photocopier. Below are some standard sizes for paper and canvases and the percentages at which to decrease or increase the template:

8" x 10": reduce template to 85% 11" x 14": enlarge template to 125%

Introduction to Color

Color can communicate feelings, mood, time of day, seasons, and emotions. Knowing how colors work, and how they work together, is key to refining your ability to communicate using color.

The Color Wheel

A color wheel is a visual representation of colors arranged according to their chromatic relationship. The basic color wheel consists of 12 colors that can be broken down into three different groups: primary colors, secondary colors, and tertiary colors.

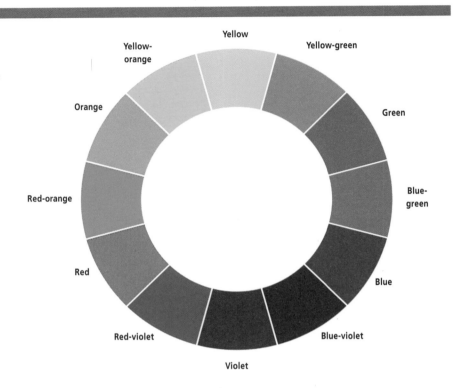

CREATING WHEEL REFERENCES

One of the easiest things to create is a 12-color color wheel with just the three primaries: red, yellow, and blue. All colors are derived from these three. Beginners should make a color wheel with both the primaries and secondaries. This can help you understand how to create additional colors, see how colors interact, and see your palette of colors in spectrum order.

Color wheel made with three primaries

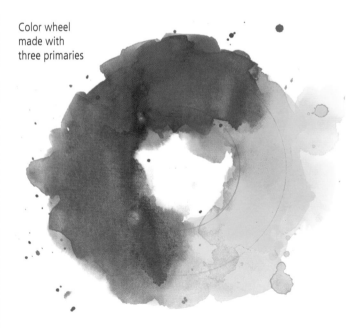

Color wheel made with primaries and secondaries

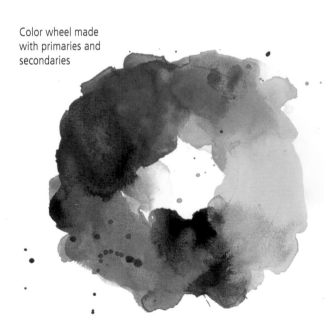

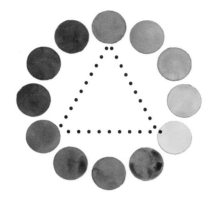

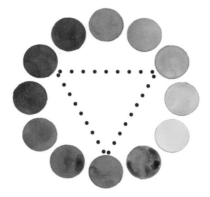

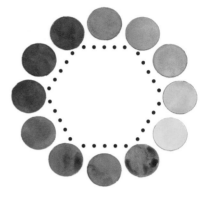

Primary Colors

The primary colors—red, yellow, and blue—cannot be created by mixing any other colors, but in theory, all other colors can be mixed from them.

Secondary Colors

Secondary colors are created by mixing any two primary colors; they are between the primary colors on the color wheel. Orange, green, and purple are secondary colors.

Tertiary Colors

If you mix a primary color with its adjacent secondary color, you create a tertiary color. Tertiary colors are red-orange, red-violet, yellow-orange, yellow-green, blue-green, and blue-violet.

Color Schemes

Choosing and applying a *color scheme* (or a selection of related colors) in your art can help you achieve unity, harmony, or dynamic contrasts. Below is a variety of common color combinations. Explore these different schemes to familiarize yourself with the nature of color relationships.

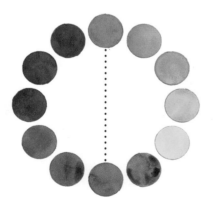

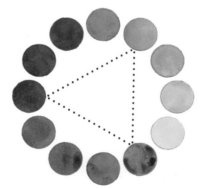

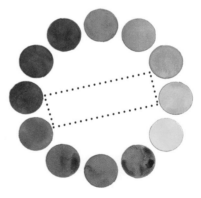

Complementary Color Scheme

Complementary colors sit opposite each other on the color wheel. Red and green (shown above), orange and blue, and yellow and purple are examples of complementary colors. When placed adjacent to each other, complements make each other appear brighter. When mixed, they neutralize (or gray) each other.

Triadic Color Scheme

This scheme consists of three colors that form an equilateral triangle on the color wheel. An example of this would be blue-violet, red-orange, and yellow-green (shown above). This color scheme provides both color contrast and natural color balance.

Tetradic Color Scheme

Four colors that form a square or rectangle on the color wheel create a tetradic color scheme. This color scheme includes two pairs of complementary colors, such as orange and blue and yellow-orange and blue-violet (shown above). This is also known as a "double-complementary" color scheme.

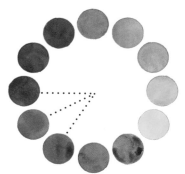

Analogous Color Scheme
Analogous colors are adjacent (or close) to each other on the color wheel. Analogous color schemes are good for creating unity because the colors are already related. You can do a tight analogous scheme (a very small range of colors) or a loose analogous scheme (a larger range of related colors). A tight analogous color scheme would be blue-violet, blue, and blue-green (shown at left). A loose analogous scheme would be blue, violet, and red.

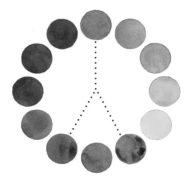

Split-Complementary Color Scheme This scheme includes a main color and a color on each side of its complement. An example of this (shown at left) would be red, yellow-green, and blue-green.

COLOR TEMPERATURE

Divide the color wheel in half by drawing a line from a point between red and red-violet to a point between yellow-green and green to identify the warm colors (reds, oranges, and yellows) and the cool colors (greens, blues, and purples). Warm colors tend to advance toward the viewer and appear more active, whereas cool colors recede and provide a sense of calm. Remember these important points about color temperature as you plan your artwork.

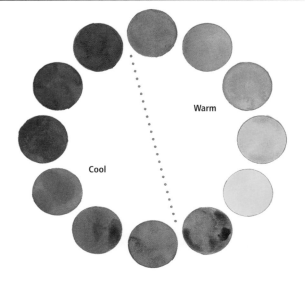

Mood and Temperature

Studies show that color schemes make us feel certain ways. Warm colors, such as red, orange, yellow, and light green, are exciting and energetic. Cool colors, such as dark green, blue, and purple, are calming and soothing. Use these colors schemes as tools to express mood in your art.

Warm Palette Here the mood is hot, vibrant, and passionate. Energetic reds and oranges contrast the cool accents of blue and purple.

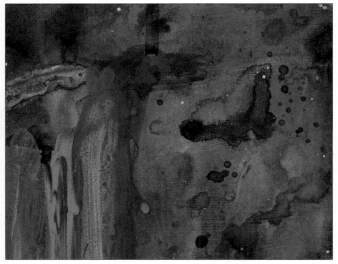

Cool Palette In this painting the mood is calm and gentle. The red-orange accents create an exciting counterpoint to the overall palette of cool greens and blues.

CONVEYING MOOD WITH COLOR

A work of art should be primarily one temperature (warm or cool); however, warm accents in a cool painting (and vice versa) are acceptable and encouraged. Remember, you want your statement to be exciting but clear.

▶ **Dark Palette** The darker colors in the cool range communicate a heavier mood. Here the analogous color scheme of cool, darker colors indicate the quiet end of the day and the approaching night.

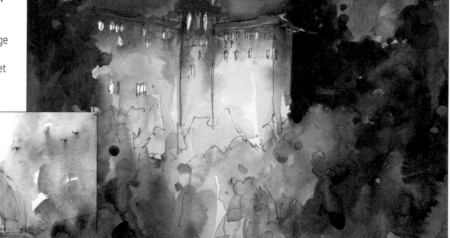

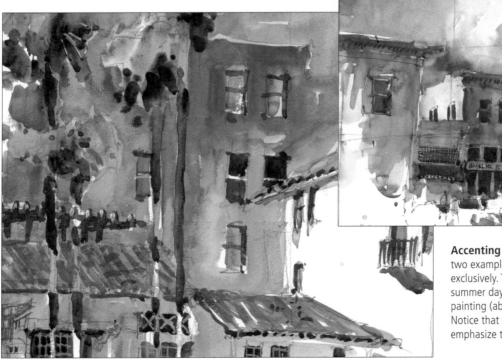

◀ **Bright Palette** Pure, warm colors with plenty of white paper showing through express the cheer of this light-hearted scene. Complementary colors (e.g., red against green or yellow against purple) also help enliven the story.

Accenting Warm and Cool Palettes These two examples feature warm and cool colors almost exclusively. The warm painting (left) suggests a hot summer day with energy in the air, and the cool painting (above) suggests a quiet winter afternoon. Notice that in each case, complementary accents emphasize the color theme with contrast.

Colored Pencil Tips & Techniques

Colored pencils are wood-encased leads made of pigment and wax or kaolin clay. Wax is more common and affordable. The wax leads are soft and allow for smooth, controlled blends. This medium works well on multiple surfaces, from smooth to rough to toned surfaces. Many artists find it easiest to work on a surface with at least a slight tooth.

Recommended Surfaces

• Smooth drawing paper
• Medium drawing paper
• Fine-toothed drawing paper
• Bristol board
• Toned paper

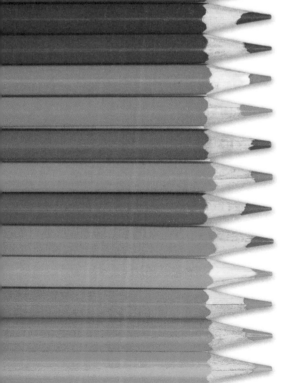

◄ Shown are wax-based colored pencils. A set of 24 colors offers a good starting point for beginners, covering the spectrum of color plus white, black, gray, and browns.

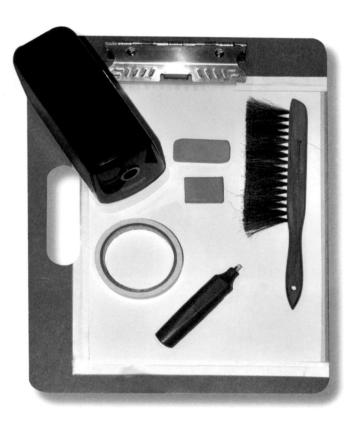

▶ Colored pencil artwork requires few supplies, but you may find the following helpful:

• Drawing board
• Electronic pencil sharpener
• Erasers
• Drafting brushes (to sweep pencil crumbs)
• Artist tape (to hold your paper in place)

Artist Tip

When using wax-based pencils, your work may develop *bloom*—a light fog over the drawing as a result of wax rising to the surface. To eliminate this, let the drawing sit for two weeks and then rub a tissue, cotton ball, or cotton pad gently over the blooms to catch and remove the wax.

Varying Strokes Experiment with the tip of your pencil as you create a variety of marks, from tapering strokes to circular scribbles.

Gradating To create a gradation with one color, stroke side to side with heavy pressure and lighten the pressure as you move away, exposing more of the white paper beneath the color.

Layering You can optically mix colored pencils by layering them lightly on paper. In this example, observe how layering yellow over blue creates green.

Blending To blend one color into the next, lighten the pressure of your pencil and overlap the strokes where the colors meet.

Hatching & Crosshatching Add shading and texture to your work with hatching (parallel lines) and crosshatching (layers of parallel lines applied at varying angles).

Stippling Apply small dots of color to create texture or shading. The closer together the dots, the darker the stippling will "read" to the eye.

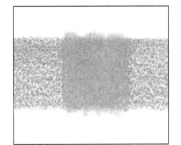

Burnishing For a smooth, shiny effect, burnish by stroking over a layer with a colorless blender, a white colored pencil (to lighten), or another color (to shift the hue) using heavy pressure. Burnishing pushes the color into the tooth and distributes the pigment for smooth coverage.

Scumbling Create this effect by scribbling your pencil over the surface of the paper in a random manner, creating an organic mass of color. Changing the pressure and the amount of time you linger over the same area will increase or decrease the value of the color.

Artist Tip

Colored pencil does not lift from the paper as easily as graphite or charcoal; some residue will almost always stay behind. If you must erase, an electric vinyl eraser will deliver the best results.

Oil & Acrylic Tips & Techniques

Although they are two different mediums, oil and acrylic share some similarities and can be worked with in a similar manner. Read on to learn about some of the differences and what supplies you'll need for each.

OIL

Oil Surfaces

Canvas and wood panel are the most suitable surfaces for oil painting. The surface must be sealed and primed properly to create a bright white ground, prevent impurities from leaching into the paint, and curb warping and rotting. If your support is not pre-primed, you can apply sizing followed by oil or alkyd ground—or you can simply apply acrylic ground.

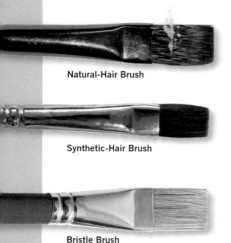

Natural-Hair Brush

Synthetic-Hair Brush

Bristle Brush

Oil Brushes

A selection of hog bristle brushes is a staple for all oil painters. These tough bristles are strong enough to both push thick paint across the surface and withstand the corrosive nature of oils and solvents. For blending and detail work, it's a good idea to also have a few soft-hair sable brushes.

Starter Set of Brushes

- Large, medium, and small flat bristle brushes
- Small round bristle brush
- Medium filbert bristle brush
- Medium and small sable brushes
- Sable liner brush

Note: See page 11 for details on brush shapes.

Drying Oils & Mediums

Drying oils and mediums allow you to change the consistency and reflective quality of the paint. While you can paint straight from the tube, most artists add medium to extend the paint and build a painting in the traditional "fat over lean" process. Some popular drying oils and resins (also referred to as "mediums") include: linseed oil, poppy seed oil, walnut oil, safflower oil, alkyd medium, copal medium, damar varnish medium, and beeswax medium.

Additional Supplies

Additional supplies you should have on hand for painting with oil include a mixing palette, an easel or painting board, paper towels and soft rags for cleanup, and several containers for holding oils and mediums.

Warning

Oil painting involves a number of hazardous materials. It's important to know safe handling habits before you begin and to work in a well-ventilated area.

Solvents

Because oil paints do not mix with water, artists traditionally use solvents for paint thinning and cleanup. If you choose to purchase a solvent, be sure it is intended for fine-art purposes. Note any instructions and cautions provided by the manufacturer. Solvents include: turpentine, mineral spirits, odorless mineral spirits, and citrus-based solvents.

ACRYLIC

Acrylic Surfaces

Acrylic is the most versatile paint for fine artists and can be applied to variety of surfaces, from watercolor and canvas paper to hardboard, wood, and traditional canvas. You can apply acrylic paint to any surface, as long as it isn't waxy or oily.

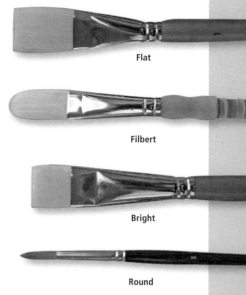

Flat

Filbert

Bright

Round

Acrylic Brushes

Synthetic brushes are the best choice for acrylic painting because their strong filaments can withstand the caustic nature of acrylic.

Starter Set of Brushes

- Small, medium, and large flat brushes
- Medium round brushes
- Liner brush
- Medium filbert brush
- Medium fan brush

▶ Flat brushes are good for washes and filling in large areas of color, but you can also use the sharp edge for more tight painting. Filbert brushes are good for blending because the flat-meets-oval shape softens the appearance of strokes. Bright brushes are easier to control, making them ideal for close-up work and detail. Round brushes come to a tapered tip, making them perfect for drawing with paint.

Acrylic Mediums & Additive

A vast array of acrylic mediums and additives allows you to experiment endlessly with the consistency, sheen, and behavior of your paint. These liquids, gels, and pastes are fun additions that can breathe life into your painting and encourage creativity.

Artist Tip

The best way to handle gels and pastes is with a palette or painting knife. Use the knife to scoop the mediums out of containers, mix them with paint, or spread them over your painting surface.

Flat Wash To create a thin wash of flat color, thin the paint and stroke it evenly across your surface. For large areas, stroke in overlapping horizontal bands, retracing strokes when necessary to smooth out the color.

Glazing You can apply a thin layer of acrylic or oil over another color to optically mix the colors. Soft gels are great mediums for creating luminous glazes. Shown here are ultramarine blue (left) and lemon yellow (right) glazed over a mix of permanent rose and Naples yellow.

Graduated Blend To create a gradual blend of one color into another, stroke the two different colors onto the canvas horizontally, leaving a gap between them. Continue to stroke horizontally, moving down with each stroke to pull one color into the next. Retrace your strokes where necessary to create a smooth blend between colors.

Drybrushing Load your brush and then dab the bristles on a paper towel to remove excess paint. Drag the bristles lightly over your surface so that the highest areas of the canvas or paper catch the paint and create a coarse texture. The technique works best when used sparingly.

Dabbing Load your brush with thick paint and then use press-and-lift motions to apply irregular dabs of paint to your surface. For more depth, apply several layers of dabbing, working from dark to light. Dabbing is great for suggesting foliage and flowers.

Scumbling This technique refers to a light, irregular layer of paint. Load a brush with a bit of slightly thinned paint, and use a scrubbing motion to push paint over your surface.

Painting Knife Applying paint with a painting knife can result in thick, lively strokes that feature variation in color, value, and height.

Spattering First cover any area you don't want to spatter with a sheet of paper. Load your brush with thinned paint and tap it over a finger to fling droplets of paint onto the paper. You can also load your brush and then run a fingertip over the bristles to create a spray.

Sponging Applying paint by dabbing with a sponge can create interesting, spontaneous shapes. Layer multiple colors to suggest depth. You can also use sponges to apply flat washes with thinned paint.

Scraping Create more detailed designs by scraping away paint. Using the tip of a painting knife or the end of a brush handle, "draw" into the paint to remove it from the canvas. For tapering strokes that suggest grass, stroke swiftly and lift at the end of each stroke.

Stippling Apply small, closely placed dots of paint. The closer the dots, the finer the texture and the more it will take on the color and tone of the stippled paint. You can also use stippling to optically mix colors; for example, stippling blue and yellow in an area can create the illusion of green. You can dot on paint using the tip of a round brush, or you can create more uniform dots by using the end of a paintbrush handle.

Wiping Away Use a soft rag or paper towel to wipe away wet paint from your canvas. You can use this technique to remove mistakes or to create a design within your work. Some pigments, such as permanent rose (above with Naples yellow), will leave behind more color than others.

Watercolor Tips & Techniques

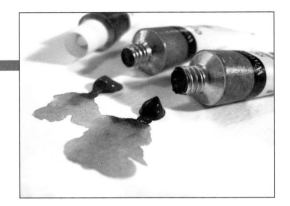

Watercolor's airy and atmospheric qualities set it apart from other painting media. This fluid medium requires a bit of practice to master, but with enough time you will soon discover how to quickly suggest form and color with just a few brushstrokes. Watercolor is available in tubes, pans, semi-moist pots, and pencils.

WATERCOLOR MATERIALS

Watercolor Surfaces
Watercolor paper, which is treated with sizing to reduce the surface's absorbency, is available in myriad sizes, weights, textures, and format. Secure your paper to a table or board with artist tape or clips and work on a flat surface.

Kolinsky Sable

Watercolor Brushes
Use sable brushes or soft-hair synthetic brushes to work in watercolor. It's a good idea to keep a couple of bristle brushes on hand for textured strokes.

Watercolor Palettes
A range of mixing palettes is available, from simple white plastic to porcelain. Choose one that suits your personal preference.

Types of Watercolor

- **Tubes** contain moist paint that is readily mixable. It only takes a small amount of tube paint to create large washes. Start with a pea-sized amount, add water, and then add more paint if needed.
- **Pans**, also called cakes, are dry or semi-moist blocks of watercolor. To activate the paint, stroke over the blocks with a wet brush.
- **Semi-moist pots** are gummy-looking watercolors that are similar to pans. Activate the paint by stroking over the color with a wet brush.
- **Watercolor pencils** combine the fluid nature of watercolor with the control of pencil drawing. Featuring leads of hard watercolor, they are great for creating fine details or sketching a composition. You can also use them with a wet brush to develop an entire work.

Flat Wash A flat wash is a thin layer of paint applied evenly to your paper. First wet the paper, and then load your brush with a mix of watercolor and water. Stroke horizontally across the paper and move from top to bottom, overlapping the strokes as you progress.

Spattering First cover any area you don't want to spatter with a sheet of paper. Load your brush with a wet wash and tap the brush over a finger to fling droplets of paint onto the paper. You can also load your brush and then run the tip of a finger over the bristles to create a spray.

Gradated Wash A gradated (or graduated) wash moves slowly from dark to light. Apply a strong wash of color and stroke in horizontal bands as you move away, adding water to successive strokes.

Drybrushing Load your brush with a strong mix of paint, and then dab the hairs on a paper towel to remove excess moisture. Drag the bristles lightly over the paper so that tooth catches the paint and creates a coarse texture.

Using Salt For a mottled texture, sprinkle salt over a wet or damp wash. The salt will absorb the wash to reveal the white of the paper in interesting starlike shapes. The finer the salt crystals, the finer the resulting texture. For a similar but less dramatic effect, simply squirt a spray bottle of water over a damp wash.

Wet-into-Wet Stroke water over your paper and allow it to soak in. Wet the surface again and wait for the paper to take on a matte sheen; then load your brush with rich color and stroke over your surface. The moisture will grab the pigments and pull them across the paper to create feathery soft blends.

Tilting To pull colors into each other, apply two washes side by side and tilt the paper while wet so one flows into the next. This creates interesting drips and irregular edges.

Applying with a Sponge In addition to creating flat washes, sponges can help you create irregular, mottled areas of color.

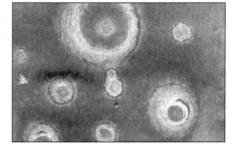

Using Alcohol To create interesting circular formations within a wash, use an eyedropper to drop alcohol into a damp wash. Change the sizes of your drops for variation.

Backruns Backruns, or "blooms," create interest within washes by leaving behind flower-shaped edges where a wet wash meets a damp wash. First stroke a wash onto your paper. Let the wash settle for a minute or so, and then stroke on another wash (or add a drop of pure water).

Pastel Tips & Techniques

Pastel offers rich, painterly effects without the hassle of wet media. Pastels are available in both hard and soft varieties. Paper is an important part of the pastel equation. No matter what type of pastel you choose, work on paper that has a textured surface so the raised areas catch and hold the pastel. You can also use toned paper, which enriches the colors with a subtle, uniting hue and prevents distracting bits of white paper from showing through.

Recommended Surfaces

- Rough drawing paper
- Fine-toothed drawing paper
- Sanded pastel paper
- Cold-pressed paper
- Laid drawing paper
- Toned paper (with tooth)

Note: Some manufacturers offer "pastel paper" or "sanded pastel paper." These surfaces generally have a mesh or finely rough texture, respectively.

▲ Generally used alongside soft pastel, hard pastel is less vibrant and is best for preliminary sketches and small details. Like soft pastel, hard pastel is available in both sticks and pencils.

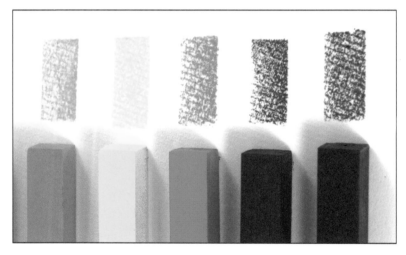

◄ Shown are soft pastel sticks accompanied by short strokes over laid paper. A set of 24 colors offers a good starting point for beginners, covering the spectrum of color plus white, black, gray, and browns. Soft pastel is also available in pencils, which wear down quickly but reduce the mess of pastel on your fingers.

OIL PASTELS

Oil pastels are sticks of pigment mixed with oil and a wax binder, giving them a smooth, creamy consistency. These richly pigmented pastels allow for expressive mark-making and blended areas of tone. You can use oil pastels on any drawing paper, canvas, wood panel, metal, glass, or even plastic!

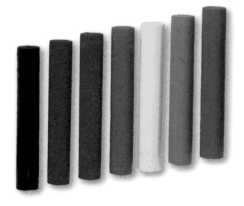

Artist Tip

You may need to warm up your sticks to help the oil pastel spread smoothly on your surface. Try warming them in your hand or holding them near a candle flame.

SOFT PASTEL TECHNIQUES

Unblended Strokes To transition from one color to another, allow your strokes to overlap where they meet. Leaving them unblended creates a raw, energetic feel and maintains the rhythm of your strokes.

Blending To create soft blends between colors, begin by overlapping strokes where two colors meet. Then pass over the area several times with a tissue, chamois, or stump to create soft blends.

Scumbling This technique involves scribbling to create a mottled texture with curved lines. Scumble over blended pastel for extra depth.

Stroking over Blends You can create rich colors and interesting contrasts of texture by stroking over areas of blended pastel.

Gradating A gradation is a smooth transition of one tone into another. To create a gradation using one pastel, begin stroking with heavy pressure and lessen your pressure as you move away from the initial strokes. At left is white gradated over a blue textured paper, lightly blended with a tissue.

Masking Use artist tape to create clean edges in your drawings or to mask out areas that should remain free of pastel.

OIL PASTEL TECHNIQUES

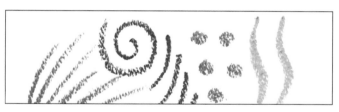

Stroking You can create a variety of expressive strokes with oil pastel, from tapered lines to stippled dots. Press and spin the end of round sticks for circular marks. Use the broad side of a pastel stick to create wide strokes that capture the full texture of your support.

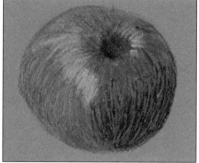

Working over Toned Paper Applying oil pastel over toned paper unifies the drawing with a hue and creates rich colors quickly without too much buildup.

Smudging Use a clean finger, blending stump, tortillon, or a chamois to smudge the pastel into smooth coverage.

Scratching Scrape lines and designs in already-applied oil pastel using the end of a paintbrush handle or a palette knife. You can "erase" oil pastel by scraping the color off the canvas.

Blending You can blend colors by stroking one color vigorously into the next, overlapping strokes where the colors meet.

Working over Other Media Oil pastel works well as a textural accent over other media such as watercolor (shown above) or acrylic washes.

Marker & Pen Tips & Techniques

Markers and felt-tip pens deliver ink from a reservoir through fibers such as nylon. They can hold a variety of inks, including non-waterproof, waterproof, alcohol-based, and spirit based. They are available in a variety of shapes.

Recommended Surfaces

- Smooth drawing paper
- Hot-pressed watercolor paper (especially if pairing with washes)
- Vellum paper
- Marker paper (especially if using spirit-based ink)

Fountain Pen A fountain pen features a split metal nib. The pen's barrel includes a reservoir of ink (sometimes in cartridge form), which eliminates the need to frequently reload the pen. Fountain pen nibs are not quite as flexible as dip pen nibs, so the line quality is limited. Most fountain pens come with caps to prevent ink from drying on the nib.

Ballpoint Pen A ballpoint pen has an ink reservoir in the barrel and a metal ball at the end that rolls along the paper, releasing ink. This pen can create even strokes, subtly tapering strokes, or subtle bone strokes (which have a bit more weight at each end), depending on the amount of pressure applied.

Soft-Pointed Tip This common tip shape has a rounded point and is available in a range of sizes. Use the tip for thin lines and the sides for thicker lines.

Brush Tip The brush tip functions much like a firm paintbrush. The fibers taper at the tip, allowing you to adjust the width of lines based on the angle and amount of pressure you apply.

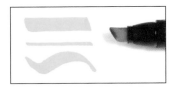

Chiseled Tip This style of tip has a flat, angled edge that can be small and subtle or wide for great coverage. It allows for thin, thick, or calligraphic strokes that vary in thickness.

Fine-Pointed Tip This tip delivers ink to the paper through a fine bunch of fibers encased in a thin metal tube. The thin, consistent lines are great for architectural sketches, comic book inking, and general sketching.

MARKER PAPER COMPARISON

Marker (brush tip and pointed tip) on marker paper produces crisp lines that don't bleed. The paper also allows for layering to darken a marker's value.

Marker (brush tip and pointed tip) on unsized, cold-pressed paper produces rough lines that readily bleed into the fibers, creating dark, irregular strokes.

Other Useful Tools

Other tools you may find helpful when working with markers include:

- Wax-based colored pencils for adding highlights.
- Water-based gouache or tempera paint for highlights and special effects.
- Straightedges and templates such as rulers, set squares, T squares, ellipse guides, and French curves to help attain smooth or sharp lines.

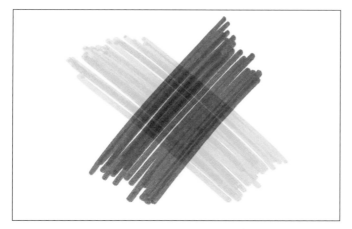

Color Mixing To mix colors with felt-tip markers, use the lightest color first. Then add the darker color.

Hatching Use a series of roughly parallel lines. The closer the lines are to each other, the denser and darker the color.

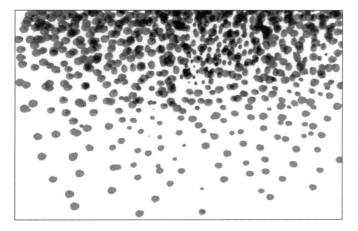

Stippling Apply small dots all over the areas you want to color. For denser coverage, apply the dots closer together.

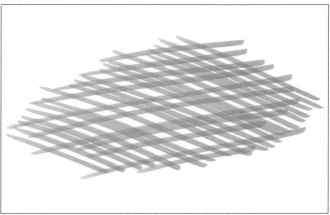

Crosshatching Lay one set of hatched lines over another, but in a different direction.

Full Coverage

To get full, dense coverage with markers, start by drawing up and down (A). Then draw side to side over the area to fill in any white (B). Work slowly to build up color.

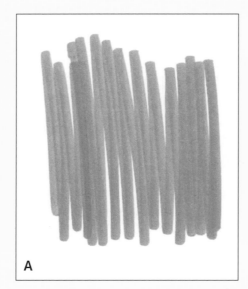

A

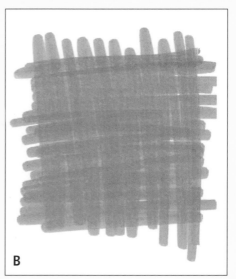

B

Panther

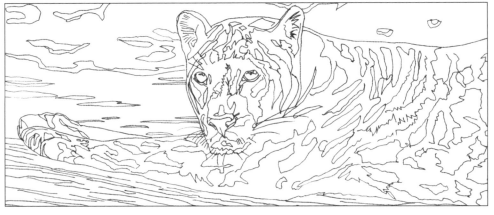

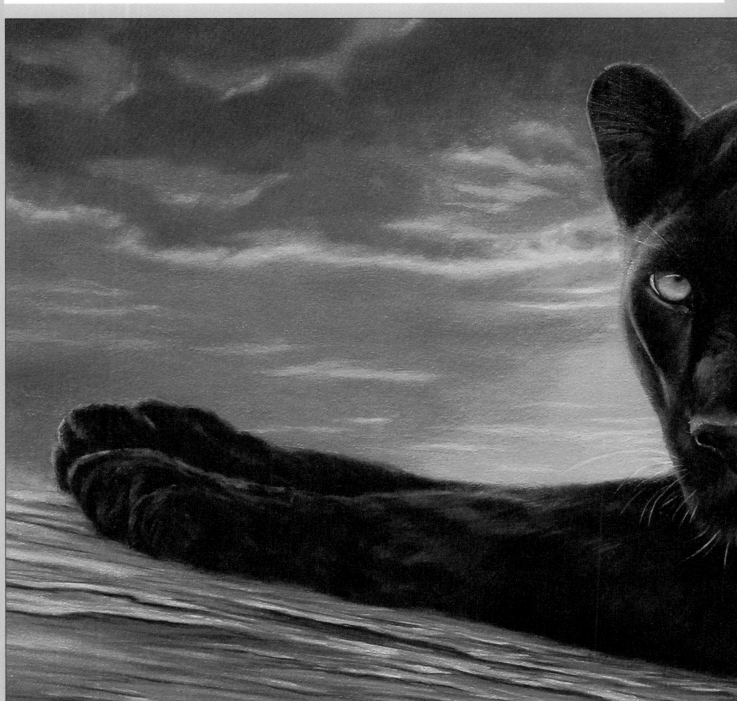

COLORS USED

○ ● YELLOW

○ ● YELLOW-OCHRE

○ ● COPPER

○ ● ORANGE

○ ● RED-ORANGE

○ ● BURNT UMBER

○ ● GRAY

○ ● BLACK

○ ● WHITE

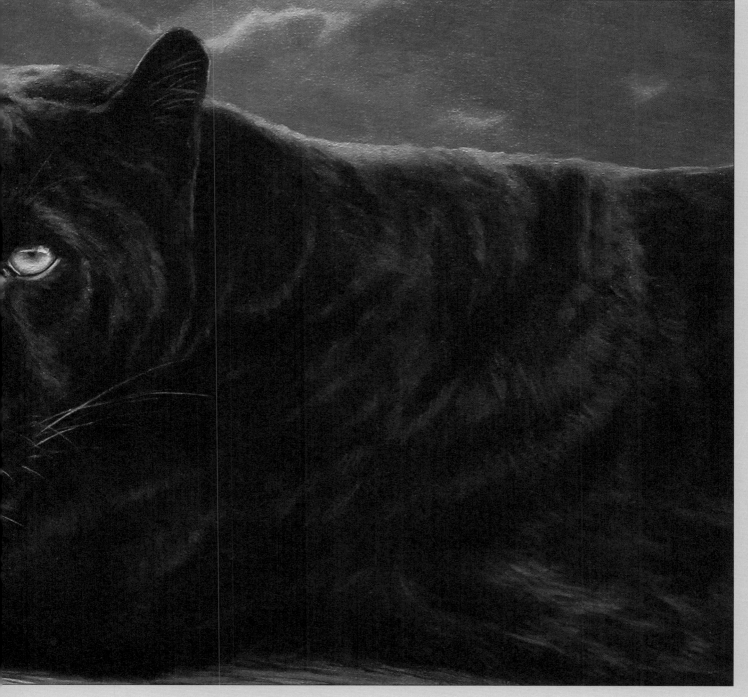

Snow Leopard

COLORS USED

test your colors here

BURNT UMBER

LIGHT GRAY

DARK GRAY

BLUE GRAY

WHITE

BLACK

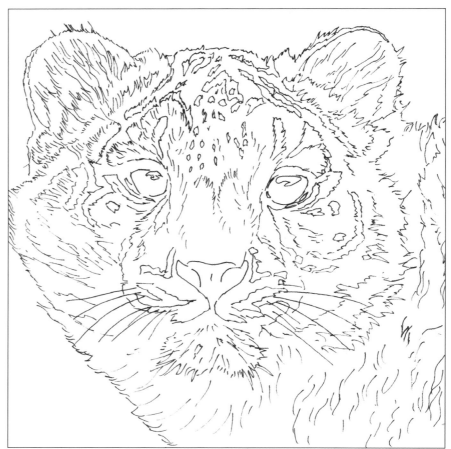

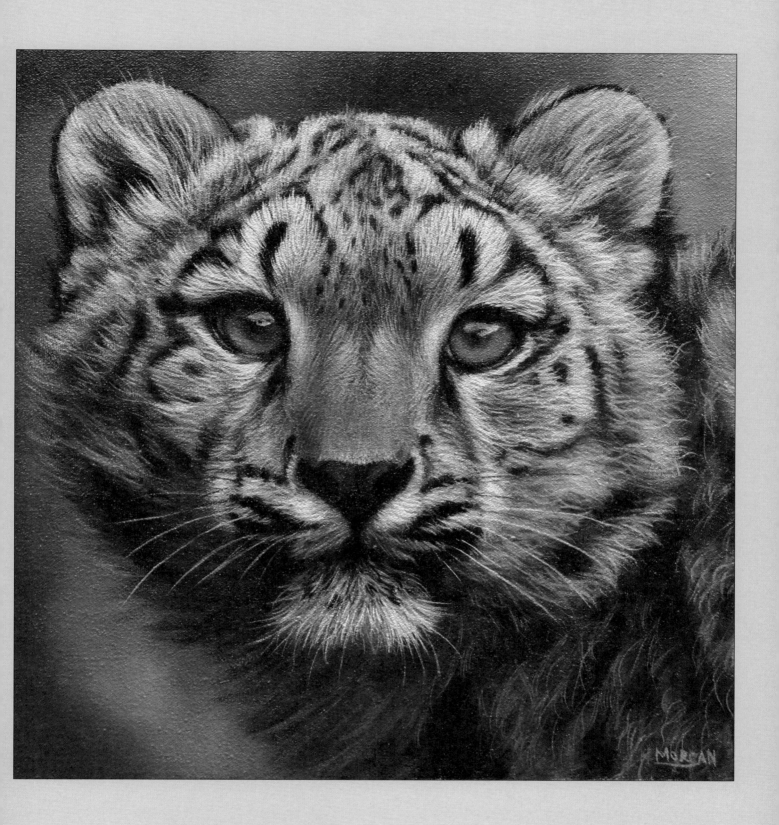

Elephant

COLORS USED

- CREAM
- YELLOW OCHRE
- BURNT UMBER
- PALE BLUE
- LIGHT GRAY
- DARK GRAY
- WHITE
- BLACK

test your colors here

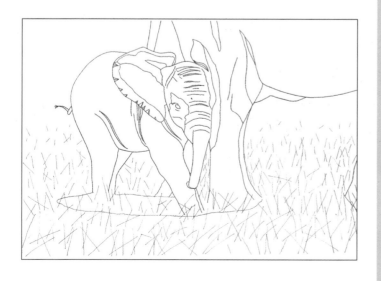

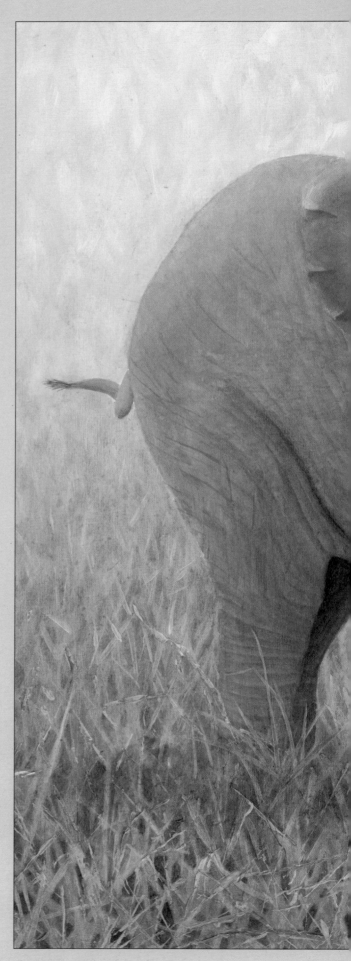

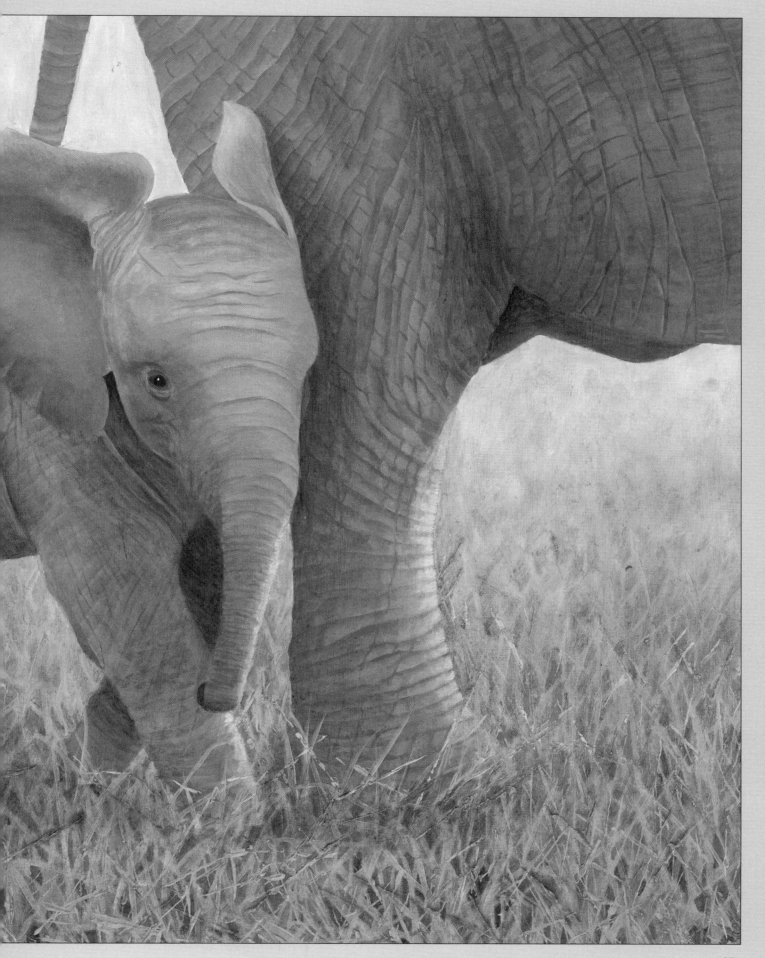

Lion

COLORS USED

test your colors here

- CREAM
- YELLOW OCHRE
- COPPER
- BURNT UMBER
- PINK
- LIGHT GRAY
- DARK GRAY
- WHITE
- BLACK

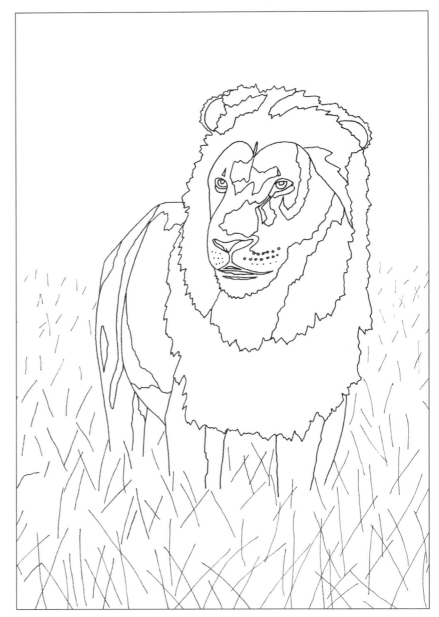

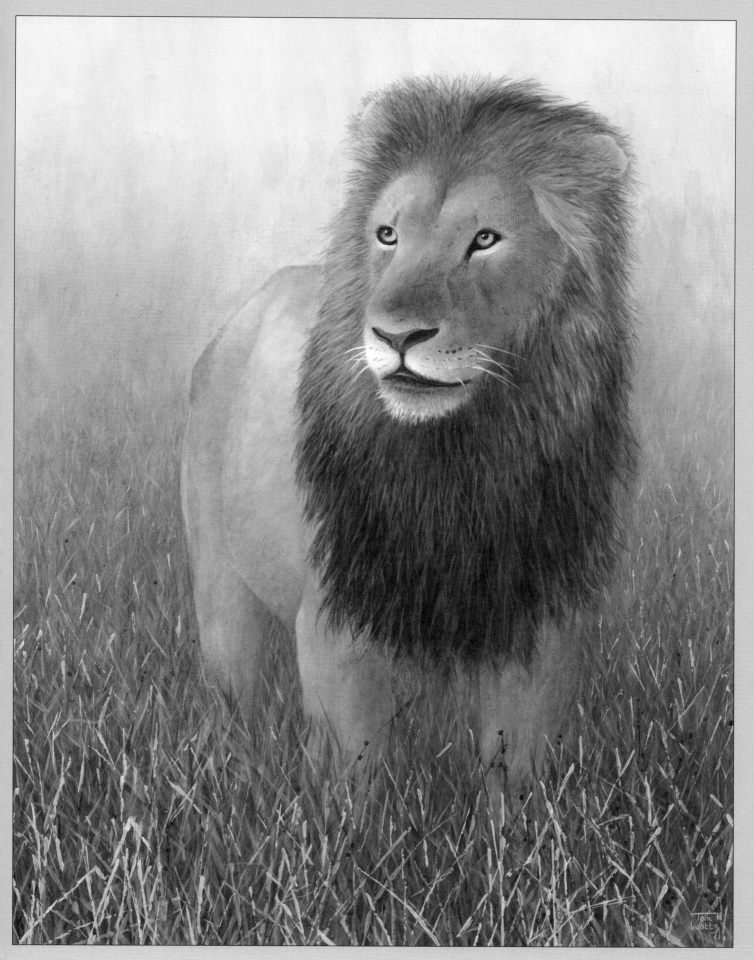

Squirrel

COLORS USED

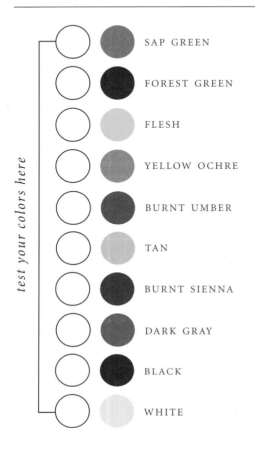

- SAP GREEN
- FOREST GREEN
- FLESH
- YELLOW OCHRE
- BURNT UMBER
- TAN
- BURNT SIENNA
- DARK GRAY
- BLACK
- WHITE

test your colors here

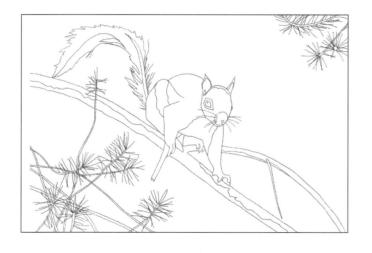

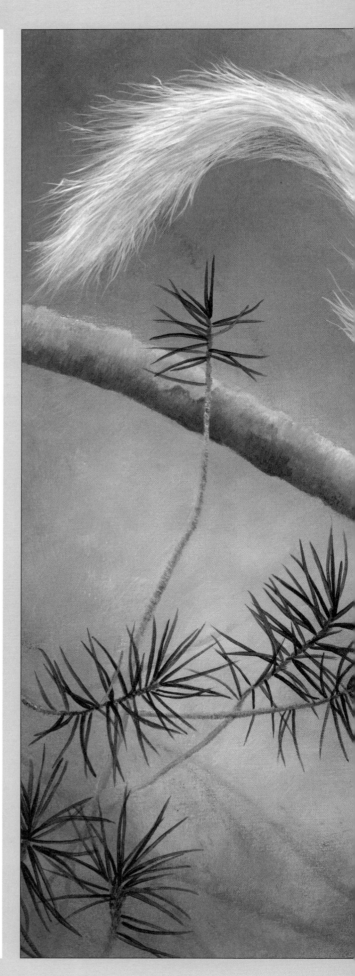

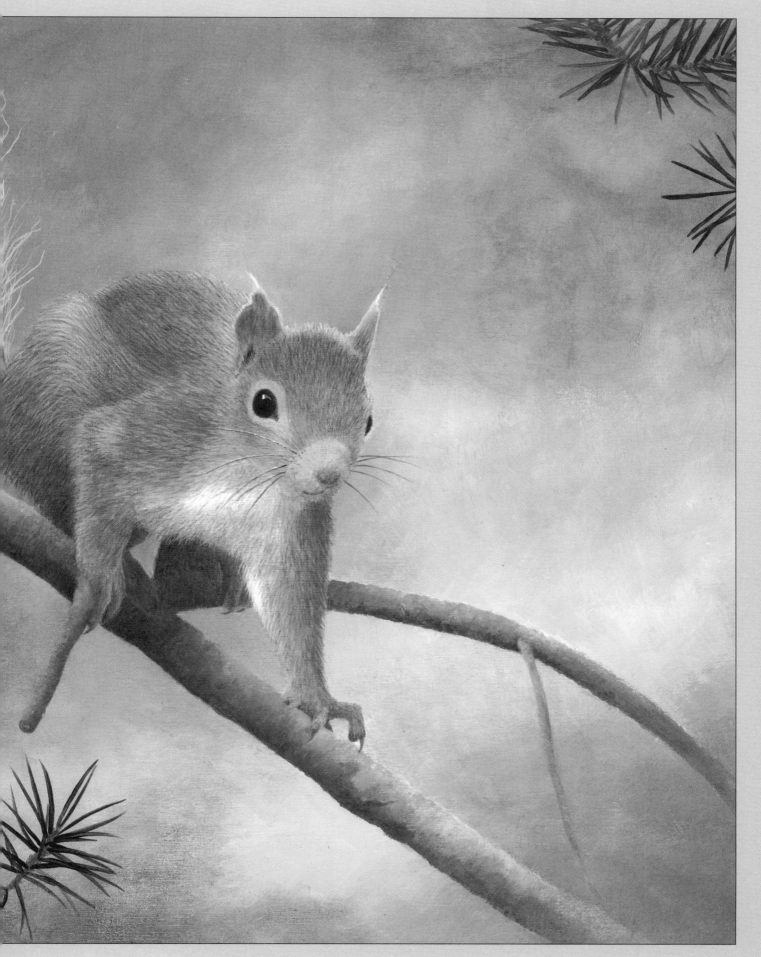

Tiger

COLORS USED

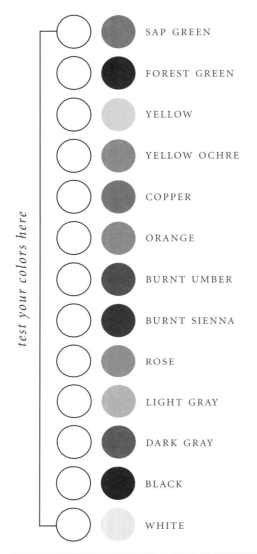

- SAP GREEN
- FOREST GREEN
- YELLOW
- YELLOW OCHRE
- COPPER
- ORANGE
- BURNT UMBER
- BURNT SIENNA
- ROSE
- LIGHT GRAY
- DARK GRAY
- BLACK
- WHITE

test your colors here

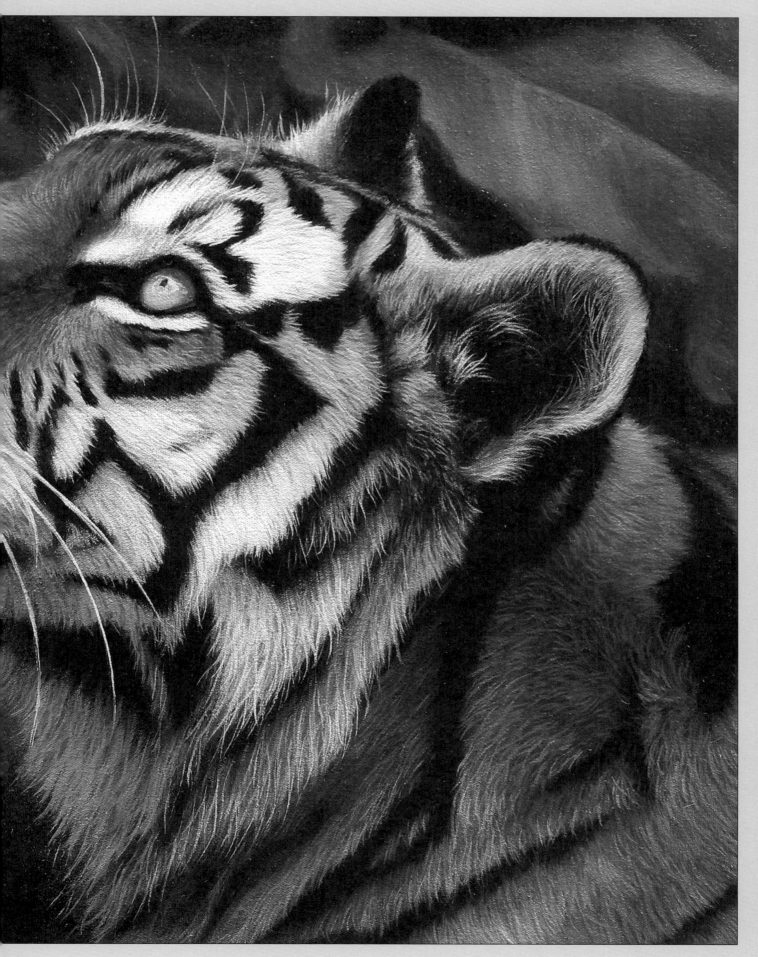

In This Series

TRACE & COLOR
IN ANY MEDIUM
FAIRIES

Trace line art onto paper or canvas, and color or paint your own masterpieces

Includes 6 templates & 4 sheets of graphite paper!

TRACE & COLOR
IN ANY MEDIUM
LANDSCAPES

Trace line art onto paper or canvas, and color or paint your own masterpieces

Includes 6 templates & 4 sheets of graphite paper!

TRACE & COLOR
IN ANY MEDIUM
STILL LIFES

Trace line art onto paper or canvas, and color or paint your own masterpieces

Includes 6 templates & 4 sheets of graphite paper!

TRACE & COLOR
IN ANY MEDIUM
FLOWERS

Trace line art onto paper or canvas, and color or paint your own masterpieces

Includes 6 templates & 4 sheets of graphite paper!

TRACE & COLOR
IN ANY MEDIUM
WILD ANIMALS

Trace line art onto paper or canvas, and color or paint your own masterpieces

Includes 6 templates & 4 sheets of graphite paper!

TRACE & COLOR
IN ANY MEDIUM
COASTAL LANDSCAPES

Trace line art onto paper or canvas, and color or paint your own masterpieces

Includes 6 templates & 4 sheets of graphite paper!

TRACE & COLOR
IN ANY MEDIUM
PETS

Trace line art onto paper or canvas, and color or paint your own masterpieces

Includes 6 templates & 4 sheets of graphite paper!

TRACE & COLOR
IN ANY MEDIUM
HORSES

Trace line art onto paper or canvas, and color or paint your own masterpieces

Includes 6 templates & 4 sheets of graphite paper!

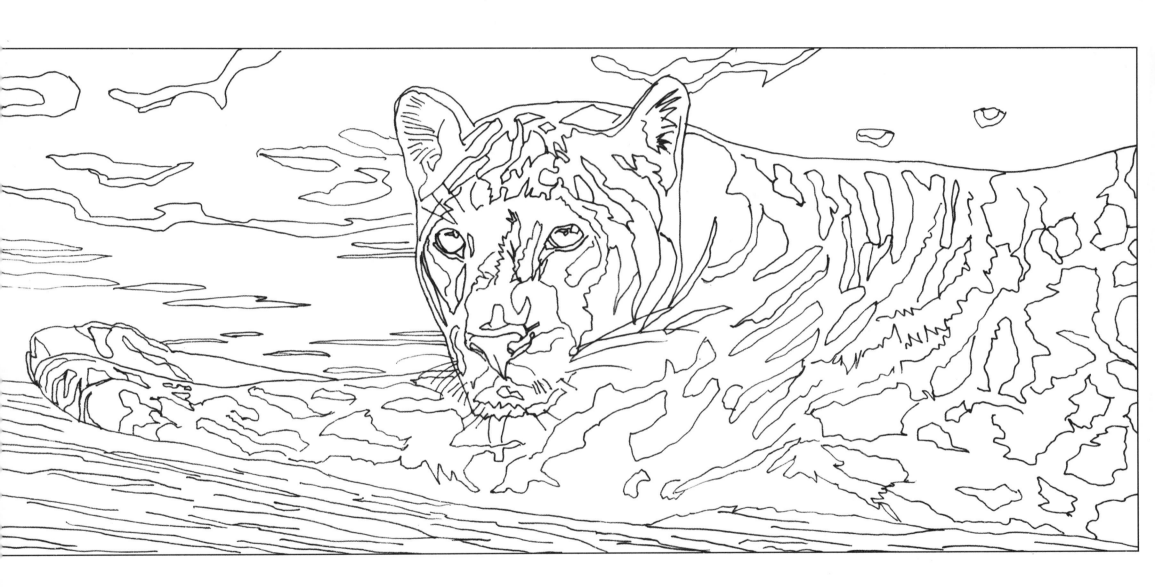

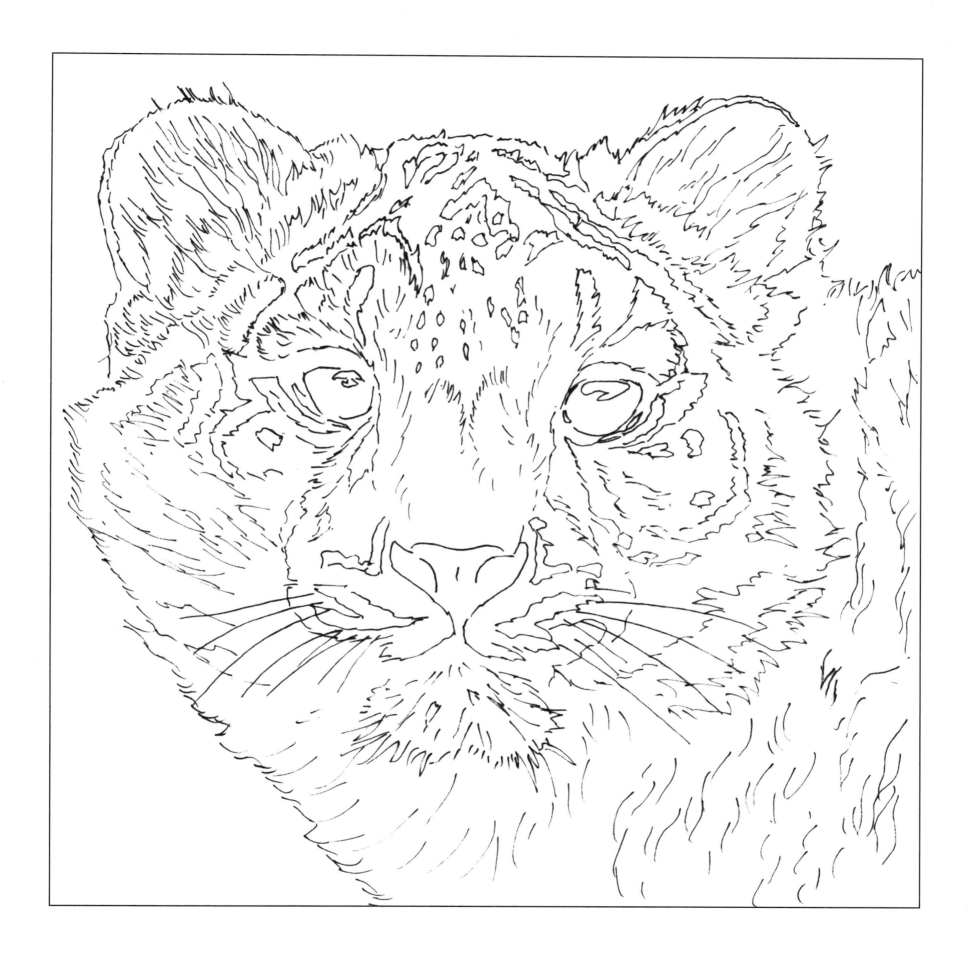

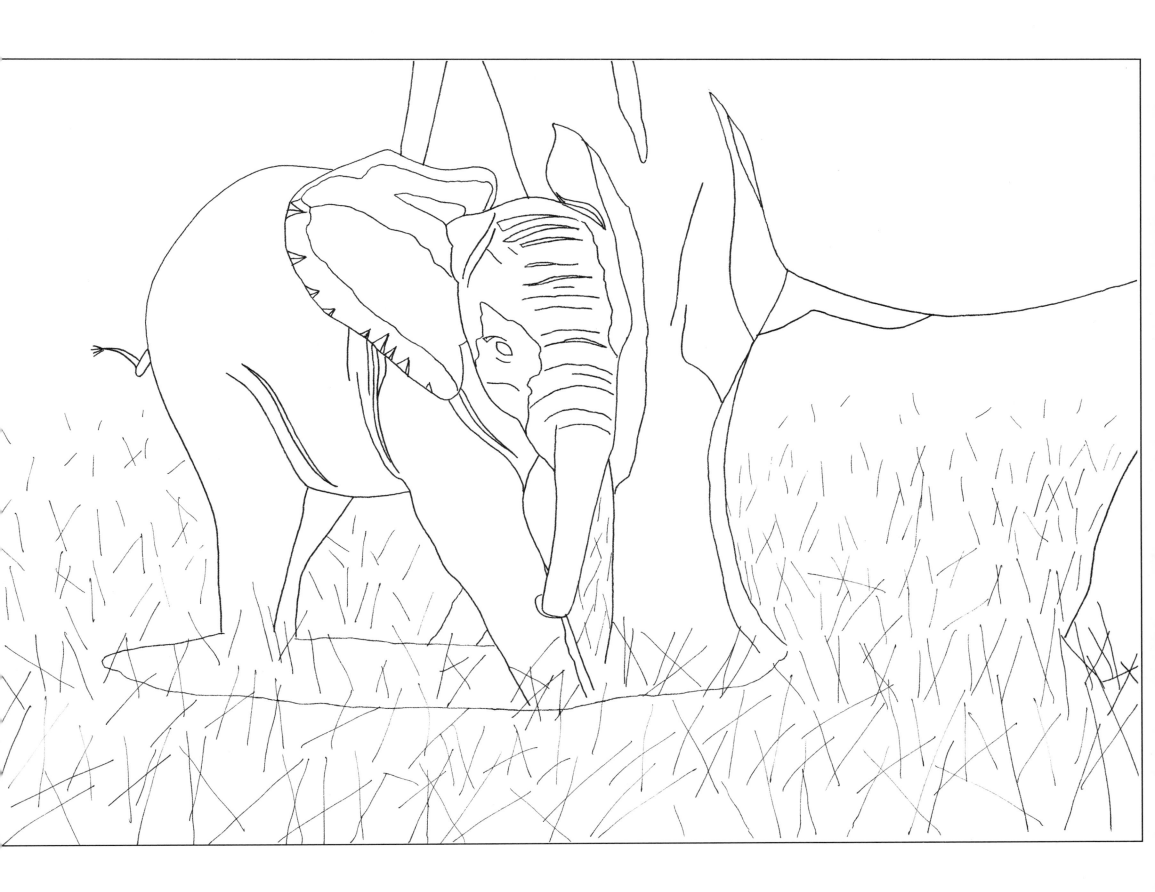

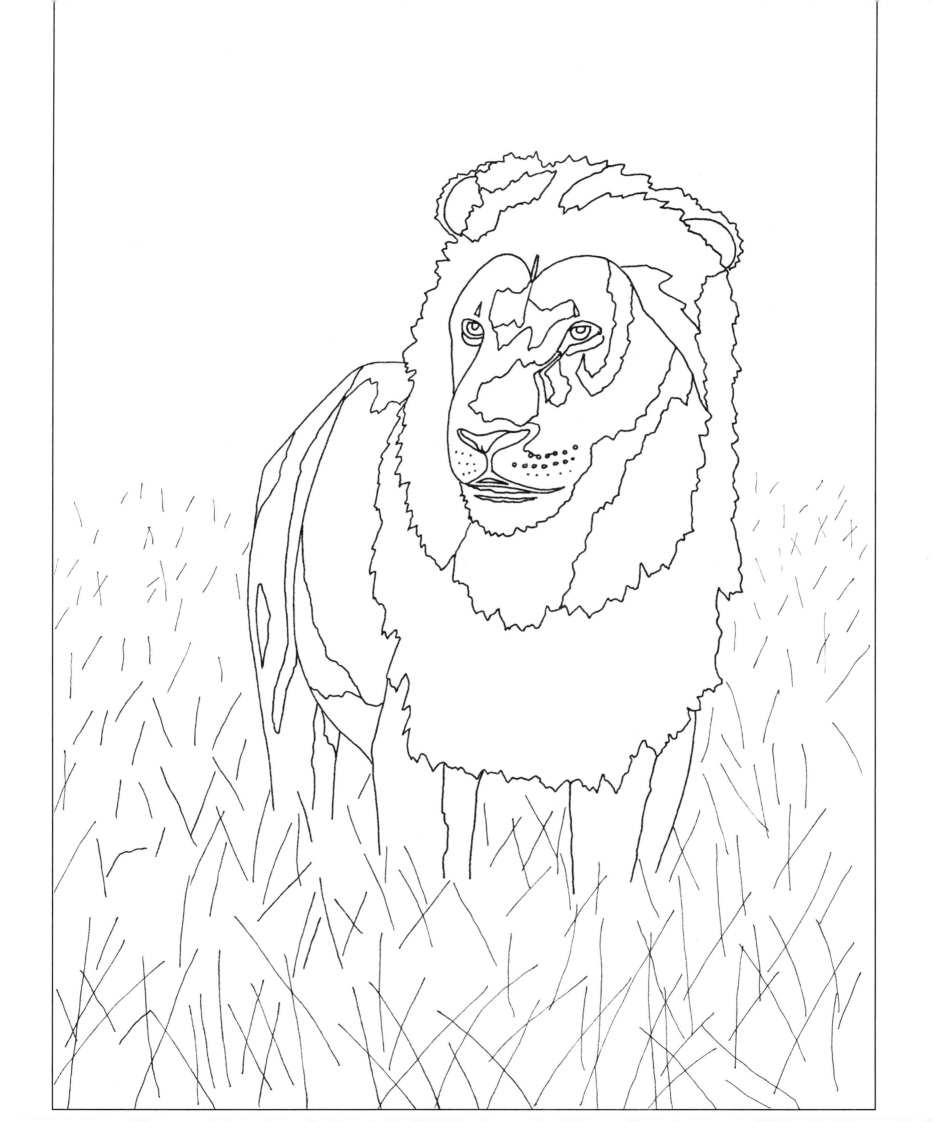

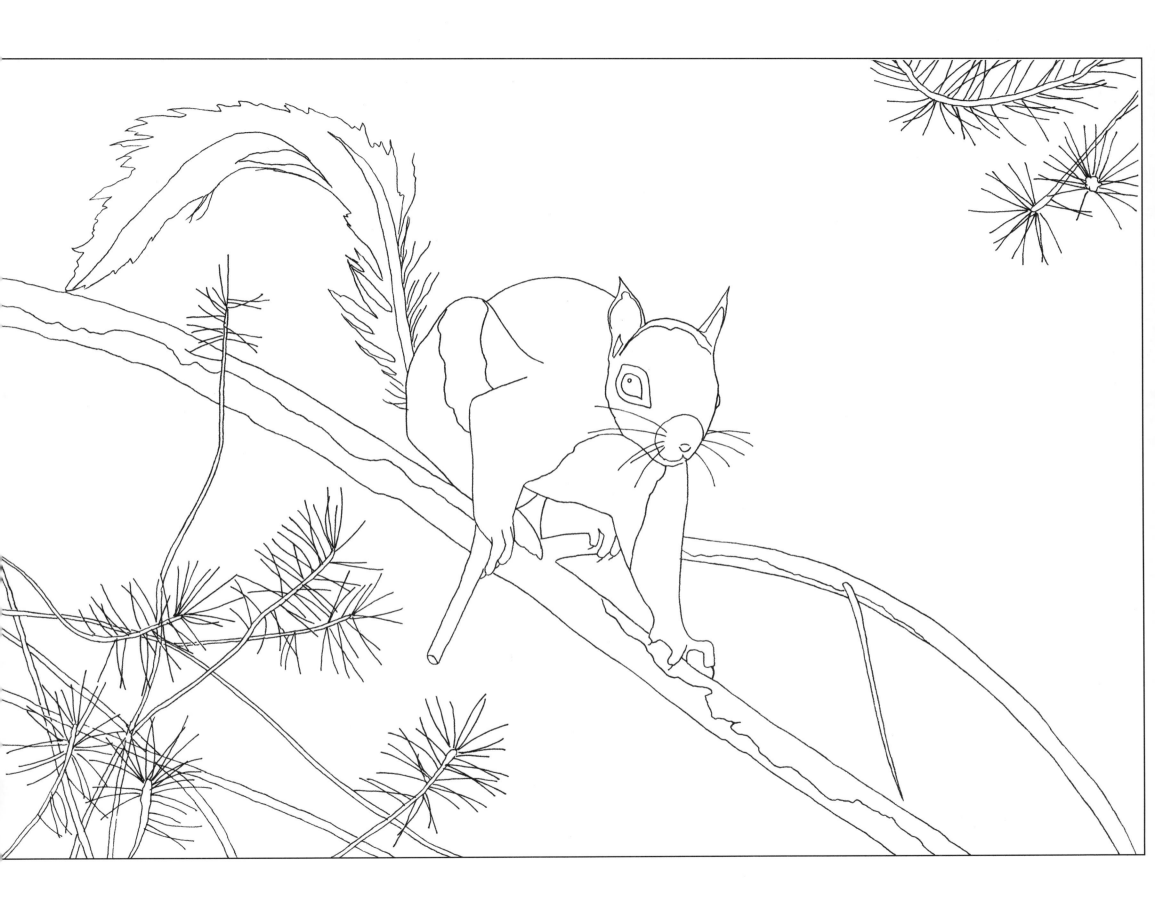

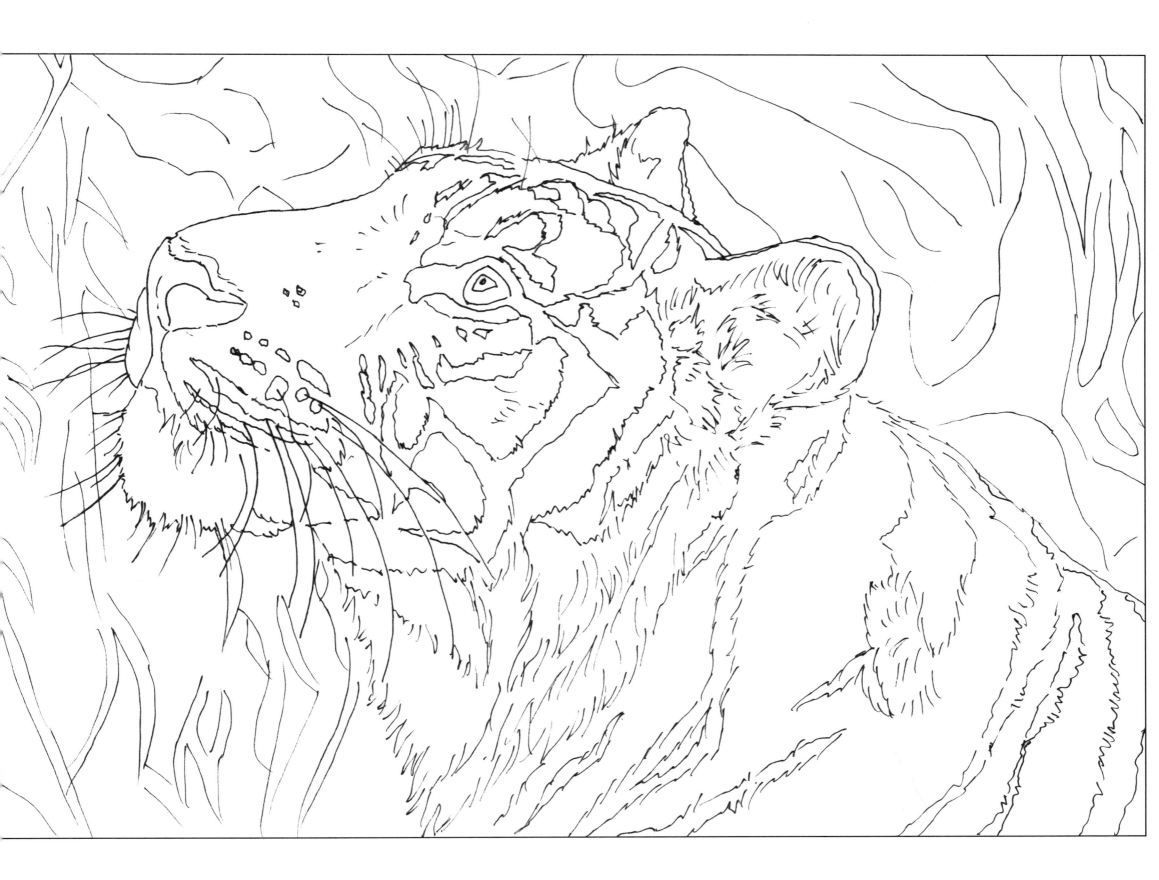